D0884486

A Painter's Psalm

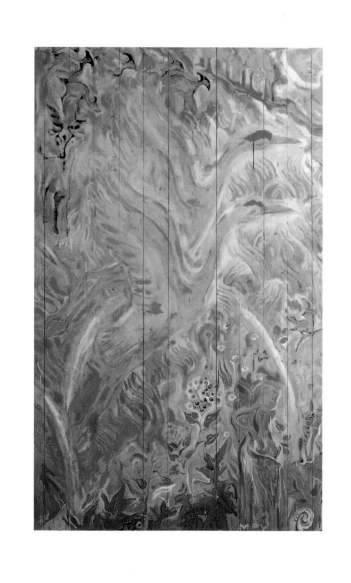

A Painter's Psalm

The Mural from Walter Anderson's Cottage

REVISED EDITION

by Redding S. Sugg, Jr.

University Press of Mississippi

JACKSON AND LONDON

The University Press of Mississippi is grateful to the
WALTER ANDERSON MUSEUM OF ART,
whose generous support and cooperation made this book possible.

Text copyright © 1992 by Redding S. Sugg, Jr.
All rights reserved
Printed in Singapore through Palace Press

95 94 93 92 4 3 2 1

Most of the photographs in this book were made by Mike Posey,
courtesy of the Walter Anderson Museum of Art. Photographs on pages 2 and 13 were
made by Gil Michael. Donald Bradburn made the photograph for plate 6 on page 20.

The paper in this book meets the guidelines for permanence and durability of the
Committee on Production Guidelines for Book Longevity of the Council on Library Resources.

Library of Congress Cataloging-in-Publication Data on page 86

CAL
ND
237
A64266
S89
1992-

IN MEMORIAM
Agnes Grinstead Anderson
1909–1991

CONTENTS

ACKNOWLEDGMENTS

In producing the original edition of this book, which was published by the Memphis State University Press in 1978, I was privileged to have the unstinted cooperation of the late Agnes Grinstead Anderson. This was part of an extended association, amounting to collaboration, which began with my edition of *The Horn Island Logs of Walter Inglis Anderson,* published by the Memphis State University Press in 1973, continued with my edition of *Walter Anderson's Illustrations of Epic and Voyage,* published by the Southern Illinois University Press in 1980, and included the revised edition of *The Horn Island Logs* published by the University Press of Mississippi in 1985. Furthermore, I have relied in revising the present work both upon Mrs. Anderson's extraordinary memoir, *Approaching the Magic Hour,* and upon some of her unpublished writing.

I am indebted to Mary Anderson Pickard for information and insights derived from her unmatched knowledge and scrupulous stewardship of her father's legacy of writing and painting.

Gregory Free, whose firm was commissioned to move the mural that is the subject of this book from Walter Anderson's cottage to the

Walter Anderson Museum of Art early in 1991, has discussed his observations with me to my advantage in appreciating the work.

The architect who designed the Walter Anderson Museum of Art, Edward E. Pickard, has provided an illuminating account of his concept of the building.

The original publication of my three books on Anderson was fostered by James D. Simmons, assistant director of the Southern Illinois University Press.

I have been fortunate in having as my editor at the University Press of Mississippi, JoAnne Prichard, who worked with me effectively on the revised edition of *The Horn Island Logs* as well as in the present venture.

I am pleased that John Langston, who beautifully designed the revised *Horn Island Logs,* has re-designed *A Painter's Psalm* in the present edition.

To my wife, Helen White Sugg, I am grateful for enthusiastic appreciation of my material combined with cool editorial concern for the style in which it has been presented.

Grateful acknowledgment is extended to the University Press of Mississippi for permission to use quotations from Agnes Grinstead Anderson, *Approaching the Magic Hour: Memories of Walter Anderson* (1989); Alfred A. Knopf, Inc., for permission to quote from "Anecdote of the Jar," by Wallace Stevens, in *The Collected Poems of Wallace Stevens* (1954); and the family of Walter Anderson for permission to quote from Anderson's unpublished writings.

A Painter's Psalm

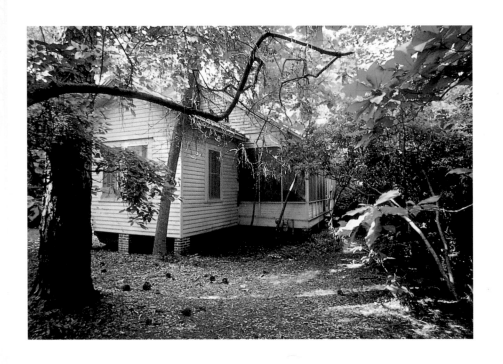

Plate 1. Walter Anderson's cottage at Shearwater in 1978

Approaches

The mural by Walter Inglis Anderson presented photographically in this little book should be approached as an element of its setting, the Mississippi Gulf Coast, which is also its subject, and as the intensely private expression of an artist who did not allow it to be seen while he lived and was ambivalent about its preservation. Today the approach is complicated by the circumstance that the work, originally located in the artist's cottage on his family's property off Shearwater Drive in Ocean Springs, was moved in the spring of 1991 to the new Walter Anderson Museum of Art on Washington Street. Painted in the early 1950s, the mural remained virtually unknown until after Anderson's death November 30, 1965. Thereafter, increasing numbers of people visited it in the cottage context. So integral a part of the painter and the place was the mural that people who knew it in the cottage sharply regretted its removal, although the tactful design of the museum and exquisite techniques of conservation offer some repayment for lost value. For full appreciation, the viewer should bring with him, as he approaches the work in the museum, an awareness of the environment in which the mural was created.

Anderson's cottage is reached by a narrow unpaved road tunnelling through tropical trees and undergrowth. The visitor first passes the kiln and workrooms of the Shearwater Pottery, which was established by Walter's brother, Peter Anderson, and then two family residences on a side road. Around a turn in the driveway, Walter's cottage appears and, beyond it, the Shearwater Pottery showroom and several other family residences. The property comprises twenty-six acres bounded, to the right of the driveway, by the mouth of Mill Dam Bayou, which became the municipal harbor after it was donated in 1948 by Walter Anderson's mother, Annette McConnell Anderson, and straight ahead by the Mississippi Sound.

A simple Creole structure of white clapboard built as slave quarters in the 1840s, Anderson's cottage stands among boles of towering pine and spreading oak, bowered in lower shrubs and trees, azalea, dogwood, and swamp magnolia. (See plate 1.) It is retired and private and was much more so during Anderson's lifetime, prior to the construction of three of the other residences that now exist. During his last years, from 1947 on, he lived there as a recluse. The vegetation, including a Cherokee rose running rampant from a collapsed arbor leading to the front steps, grew into a nearly impenetrable barrier. After his death, when people could visit the mural, much of the vegetation had been cleared, but a sense of entering a forbidden precinct remained. A strong impression of the artist's thorny isolation persisted in the cottage, causing a slightly uneasy observer to wonder whether he was guilty of impertinent intrusion.

Upon Anderson's marriage to Agnes Grinstead in 1933, his parents gave them the cottage, which he remodeled. It contained two fair-sized rooms with front and rear galleries and, at the south gabled end, a brick fireplace and chimney. He widened and made a screened porch of the front gallery. Here he designed and decorated pieces for production by the Shearwater Pottery and carved linoleum blocks for the production of prints. He hoped that these high quality but inexpensive decorative objects would both leaven popular taste and provide him with a living, so that he could reserve half his time for painting without having to consider the market. He incorporated the back gallery into the house, making a bath and dressing room, a well-lighted space for painting, and a kitchen.

By removing the partition between the two original rooms, he made a space approximately 15' x 30' with a high ceiling, the fireplace at the south end facing a wall of French casements at the other. He installed sliding double garage doors of wood panelling between the screened porch and the main room and between that and the newly enclosed rooms at the rear. The house can be opened to the air, a useful feature in that sultry climate, in a fashion reminiscent of Japanese construction. Anderson panelled the central room with 4' x 8' sheets of plywood, battened the joints, and stained walls and ceiling a silvery grey, delightful in the green atmosphere beneath the trees.

He faced the chimneypiece with red and black glazed brick, later painted white and blue since he thought the original colors made the room dark, and set the brick above the mantel in a flat hummingbird

pattern suggestive of Navajo or Zuni design. Against the long sides of the room, he built in bunks that doubled as seating, desks for his wife and himself, and bookcases. Under the casements, he installed window seats with storage space beneath. He also designed free-standing furniture for seating by the hearth and for dining by the windows. The cottage was not only remodeled and furnished by his hand but decorated as well with his paintings, pottery, prints, hooked rugs, and wood sculpture.

In 1939, after the birth of the couple's first child and with the second expected, Anderson built on a room, measuring 12' x 14', at the south end beyond the chimney, to serve as a nursery. Since 1937, however, he had suffered increasingly severe episodes of mental illness. These jeopardized a passionate marriage and idyllic family life in the cottage as well as the promising balance he had struck between the production of decorative objects for the market and a mystical commitment to painting. He completed the construction of the little room but was prevented by illness from furnishing and decorating it compatibly with the rest of the house as he presumably had intended.

Gregory Free, who supervised the removal of the mural, has suggested that in renovating the cottage Anderson reflected the Cottage Craftsman style of the 1920s. The style is also evident in The Barn, which stands near the cottage and which Anderson's mother and father remodeled and decorated as their residence, and in the Shearwater Pottery showroom. Free believes that these three buildings may be the only original instances of Craftsman architecture in Mississippi, original

in the sense that the elements were produced on the spot, not ordered from Sears, Roebuck. Since Anderson did not decorate the little room at the time he built it and since he painted the mural in it years later in very changed circumstances, without reference to the Craftsman style, the mural could be removed without damaging the integrity of the cottage as Anderson had designed it for family life. The little room has been reconstructed as it was before Anderson painted the mural in the early 1950s.

Mrs. Anderson removed herself and her children to her father's house, Oldfields, not far from Gautier near the mouth of the Pascagoula River, in 1940. There Anderson rejoined his family. Mrs. Anderson taught school. Life at Oldfields was in many respects delightful, as may be seen in Walter's "Calendar," in which over a period of years he recorded that life in ink drawings and watercolor sketches. Gradually, however, he absented himself for more frequent and longer periods alone on the islands offshore, especially Horn Island. Out there, he worked out the only way of life he felt was possible for him. He claimed his ecological niche, not so much as a naturalist, but as one creature among all the others, whose function was to paint his world.

He had to go to sea, he declared in one of his logs, in order "to escape the dominant mode on shore," and he grew less and less tolerant of even minimal family relationships and responsibilities. Toward the end of the Oldfields period, he informed his wife that he was compelled to leave her protective care. She has recorded in her memoir, *Approaching the Magic Hour,* that he said to her, "All that you give yourself

for is to see that I remain normal, to see that I live in the world and not in a hospital. I am grateful for these beautiful years, but you have to understand something, too. I *am* normal." He acknowledged that his normalcy was not that of ordinary people, which he did not condemn; but he lived "under a different compulsion." It was necessary that he be in harmony with nature at large and that he make it manifest. "I must paint," he declared. "I am going to try to order my life so that this becomes possible."

He did, in time, so order matters but could not maintain his calm, confessional tone. Toward the end of December 1946, he was aggravated by a normal domestic crisis—a sick child's coughing—and stormed out of the house at Oldfields into the night. He was furious also because he had realized his wife was pregnant with their fourth child, whose paternity he cruelly denied. He stormed back in and yelled to her, "I came to tell you that I'm leaving. I'm not coming back, ever! I can't take it. I'm an artist; I have to be." Those were the terms on which he moved back into the cottage at Shearwater. For the rest of his life, he spent only the time there required to decorate the ten pieces a week he owed the Shearwater Pottery, then vanished in his skiff to spend weeks at a time on his island.

During the years after 1947 of his solitary tenancy, Anderson's cottage was obscured by the heavy growth around it and, when he was away, his family respected its privacy. When in residence, he worked on the screened porch but was to be approached with circumspection. While he painted inside the cottage, he often played phonograph music,

typically Beethoven, to which he sometimes danced; his feet could be heard thudding. Sometimes in frustration he put his fist through the windowpanes. While at home, he drank and smoked too much, although he did neither on the island. He seemed to most observers to have become hopelessly what he once named himself, "the *Alienado*," his other aspect as "the islander" remaining mysterious. "As he told me he must," Mrs. Anderson has written, "he remained steady to his compulsion to create and, to all intents and purposes, was single. He was a painter always, a lover at times, a husband and father never."

It was in this ambience that the mural in the little room materialized, almost unsuspected, by May 1953, never to be seen in its entirety until after he died. He painted a watercolor of the door leading into the little room, as seen from the main room of the cottage, in which the door stands ajar and shows the color and pattern of the mural glimpsed within. (See plate 2.) On the back of the watercolor, he wrote the 1953 date. His family thinks that the cottage mural was, at one level, a proud and private retort to the town of Ocean Springs. When the town built a community center in 1950, Anderson offered to decorate the walls, according to Mrs. Anderson, "as a labor of love, as an artist's contribution to the community." He came forward in his public character as a "decorator," the word he used to describe his occupation on his passport. From the start, there was opposition from some elements of the community. People watched him at work, and some of them harassed him. Public reaction to the mural was mixed and a petition was circulated to have the mural painted over. He stopped

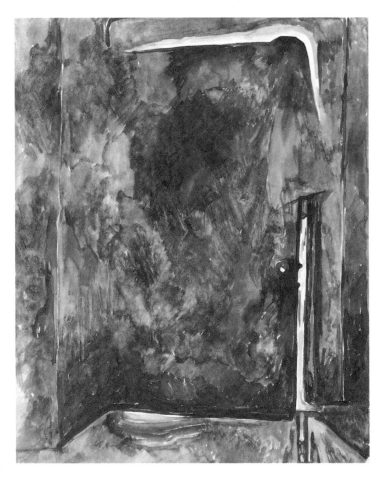

Plate 2. Watercolor by Anderson
of door to little room in cottage

painting after more than a year's labor, even though he had not finished it. For years, the community center mural, sometimes descriptively called "The Seven Climates of Ocean Springs," was subject to casual abuse. Anderson is thought to have used the leftover paint for the cottage mural, which is a lyric evocation of the area, replete with his deepest responses and motifs, and which complements the public statement made at the community center.

When Anderson's wife and her sister Patricia, Mrs. Peter Anderson, entered the cottage after his death on November 30, 1965, their first impressions seemed to confirm the common view of the cottage as the memorial of a tragically aborted talent. They crossed the screened porch, which was cluttered with the debris of his work with pottery and the impedimenta of his voyages out to the island—sodden blankets dried stiff, the garbage cans he used to carry supplies, trash. "He had not allowed anyone inside for many weeks," Mrs. Anderson has written. "The water had ceased to run in his sink and in his bathroom; he had been bringing it in from a faucet in the yard. The screens were torn and rusted out. The roof and north wall of the bathroom had been crushed by a fallen chinaberry tree. The floors of every room were littered with cigarette butts, empty bottles, and empty beer cans. A dead rat lay behind one shelf of his precious books. Old grocery boxes, overflowing with papers, stood gaping all around." The hearth and the floor around it were adrift with watercolors and the fireplace filled with the ashes of others. In the space to the rear where he had painted stood a large wicker steamer trunk. When the women opened it, they

received a double shock: of pleasure and interest, for it was filled with drawings, paintings, writings; of sickness when, after an instant, the papers heaved as the rats nesting in them fled.

They had begun to have an excited sense of treasures surviving squalor when they approached the door leading into the little room. "It had been hidden away from us, for he had kept a padlock on the door," Mrs. Anderson has recorded. Now they looked in and "found that a miracle had taken place." Patricia Anderson exclaimed, "Why, it is the Creation at sunrise!" (See plate 3.) This phrase has been used informally as a title for the work, since it expresses the feeling of joyous affirmation experienced by everyone who sees the mural. The phrase applies, however, to only one wall and tends to restrict appreciation of the whole design. In retrospect, Agnes Anderson declared that, in the moment of discovery, she had understood that "Around and beyond the piles of trash on the floor extended his land of 'infinite refreshment.'" In one of his Horn Island logs, Anderson referred to the vicinity of Shearwater as providing "land upon which to walk and infinite refreshment," continuing, however, with the statement, "but I was indifferent to that place and left in the night to go to my island." The attractive force of the island prevailed, but he could acknowledge the values of the shore and celebrate them in the mural.

The widow began to feel that, after all, "the world had not been too much with him, and he had not 'laid waste' his years." Gradually, she realized that the "crumbling cottage contained an artist's complete works; little was absent or scattered to the winds except what he had

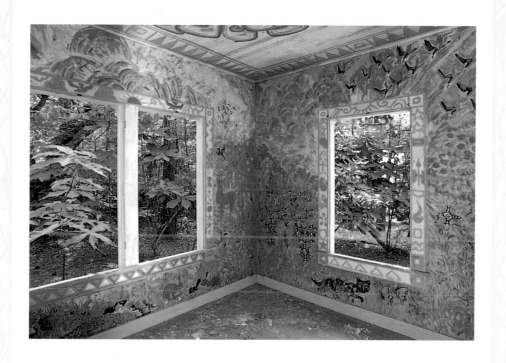

Plate 3. View of the little room from the door

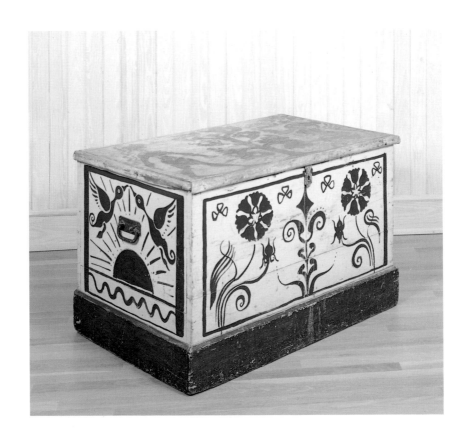

Plate 4. The chest made by Anderson,
filled with watercolors, and left in the little room

14

burned. It was there, from the earliest years to the last sketches done in the hospital." He had probably destroyed as much as he had saved or had allowed carelessly to survive, but he had not acted altogether in the merely destructive mode of "the *Alienado*." There were thousands of watercolors on 8½″ x 11″ typewriter paper (the rag content of which makes it surprisingly durable) as well as a number of large ones, thousands of pen-and-ink drawings (he had left thousands of others at Oldfields where his wife had gathered them up), and innumerable pencil sketches, many of these done as the basis for paintings and containing careful color notes. They memorialized occasions when in some blind he was up to his waist in water, "drawing in a fury of creation." And there were writings: the logs of his sojourns on the islands stuffed away in an old kitchen safe, verse, fables, aphorisms, translations.

The paintings and drawings were analyzable, the writings glossed them and preserved the texture of a subtle and learned mind, and the mural in the little room could be read as a testament, a summa of his mind and sensibility. The women found in the middle of the room, set on the paint-spattered floor and surrounded by debris, a carved wooden chest in which Anderson had left about 2,000 watercolors. (See plate 4.) Mrs. Anderson remembered that, a few days before he left the cottage for the last time, she had tried to bring him some important family news only to be refused admission and told that he was busy sorting paintings. She could now put a more hopeful interpretation upon the incident. And he had left, under the south window of the little room, a cardboard box filled with papers, including

Bless the lord oh my soul— Oh lord my god, thou art very great— thou art clothed with honor and majesty.

·Who coverest thyself with lights as with a garment, who stretchest out the heavens like a curtain:

Who layeth —the beams of his house chambers in the waters; who maketh the clouds his chariot who walketh upon the wings of the wind:

Who maketh his angels spirits; his ministers a Flaming Fire

Who layed the Foundations of the earth that it might not be removed Forever.

Thou coveredsdt it with the deep as with a garment, the waters stood above the mountains

Plate 5. Facsimile of beginning of
Psalm 104 in Anderson's handwriting

a transcription in his hand of Psalm 104 in the King James Version of the Holy Bible. This, she felt, was a more effective key to the little room than the key to the padlock he had kept on the door. (See plate 5.)

The "eureka" effect of the little room upon Anderson's wife and sister-in-law when they discovered the mural could probably never be felt by anyone else in quite the same degree. Nevertheless, it persisted through the years for everyone who made his way to the cottage and could only be radically affected by a change of setting. Part of the appeal was the very vulnerability of the work to damage, decay, destruction. This conveyed something of the artist's own love of ephemerality and the poignant quality of what he called "dramatic" painting, in which he seized the fleeting image but derived satisfaction more from the act than from the resulting record.

The decision to move the mural was finally a simple vote for preservation. The hydrothermograph recorded a constant range of from 80 to 90 percent humidity in the little room, mold develops beginning at 65 percent. Water vapor was penetrating both the paint and the wood to which it had been applied. Insects and rodents were at home in the structure. When the exterior siding was taken off, rats living in the walls at the southeast corner were found to have gnawed to within a fraction of an inch of the mural surface. The plastered surfaces of the chimney upon which Anderson had partially painted subjects indispensable in the interpretation of the mural were flaking, cracking, and becoming discolored. Cracks in the mortar between the bricks comprising the fireplace and chimney promised a conflagration. Already

the cottage had survived several hurricanes there on the waterfront. Elementary security could not be maintained, and the mural was vulnerable to damage by the considerable numbers of people who visited it more or less casually.

Because of Anderson's idiosyncratic carpentry, the mural, as compared with the fresco-like painting on the chimney, was easy to move. The little room as a whole was detachable, for Anderson had not tied it in properly with the old cottage. He constructed the interior walls, floor, and ceiling from narrow yellow pine planks. Those comprising the walls were nailed vertically to horizontal bands rather than to conventional studs. The mural, with a cut-out in the north wall where the chimney projected, was braced, extracted, cased in plywood and, looking like a big crate, hauled off and inserted into the shell prepared to receive it at the museum. In principle, it could be reinserted into the little room at the cottage with no perceptible differences.

Removal of the chimney paintings required a labor of seven days by Free and by Patricia Kamm, a conservator specializing in frescoes. Anderson had covered the back of the chimney with Portland cement, which bonded with the brick, and applied a skim coat of plaster upon which he painted, apparently when it was dry, so that the result is not a fresco. He was evidently working toward the effect he had achieved in the community center, where he had found that oil paint on rough cement walls approximated the soft look of fresco. The fireplace returns had been merely plastered, without the cement undercoat, and were flaking.

Three facings were attached to the painted surfaces of the chimney: first, a layer of rice paper, then polyestermonofilament, and finally a rigid facing of masonite. Free and Kamm then sliced the brick infrastructure at the depth of half a brick and faced and reinforced the cut brick so that the back and returns of the chimney could be laid flat. They bolted these between Alucoban sheets for transportation to the museum.

This building was conceived by its architect, Edward E. Pickard, a son-in-law of Walter Anderson, as a setting for the mural that would be an acceptable substitute for the cottage setting. Understanding Anderson to be "the quintessential outdoor-man," Pickard felt that the artist "could not have been 'brought indoors' into a museum 'building' had he not supplied three major 'indoor' works which sanctify and glorify the outdoors." These works are the mural in the community center, which became an annex of the museum, a mural entitled "Ocean Springs—Past and Present," which Anderson painted in the auditorium of the Ocean Springs High School as a W.P.A. commission in 1935, and the cottage mural.

The murals for the community center and the high school deal with the history and environs of Ocean Springs. On the south wall of the community center, Anderson represented the arrival of d'Iberville and his encounter with the Indians. Anderson humorously included himself steering the skiff with d'Iberville's crew. The opposite wall is devoted to the local flora and fauna disposed in seven distinguishable sections illustrating phases of the year. Particular allusions include, at the

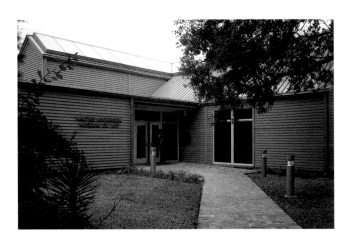

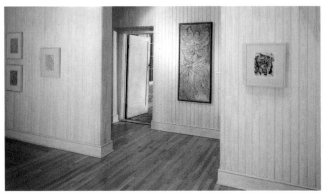

Plate 6. Exterior of the Walter Anderson Museum of Art

Plate 7. Entrance to the little room,
Walter Anderson Museum of Art

southeast corner, a large rose reminiscent of a rose window. Anderson is known to have had in mind the Dorothy Perkins roses the town had planted along U.S. Highway 90 in support of a claim to be "a city of roses."

From the community center, a long high gallery with clerestory lighting extends southward through the museum. Upon the upper walls the high school mural is mounted. One side of the mural depicts the early Indian life of the area, and the other the modern fisherfolk. Near its southern end, the long gallery is crossed by another gallery, beyond which is the vestibule of the room containing the cottage mural. Pickard has in this way organized the museum as a progress from the most public and professional of Anderson's work through rich and varied collections of his painting, pottery, prints, and sculpture to the little room that exhibits a climactic personal revelation.

The plan alludes to church architecture. The community center corresponds to the narthex, the long gallery to the nave, the cross-gallery to the transept, and the little room to the chancel. The cottage mural, oriented as it was at the cottage, stands encased in a structure allowing for a circumambient zone of air in which temperature and humidity may be controlled. In effect, the atmosphere of the cottage has been imported, for the pine boards upon which the mural is painted would contract if too well dried. Nevertheless, the view through the windows, which was an essential aspect of the mural as Anderson conceived it at the cottage, has been preserved and exterior planting similar to the growth at Shearwater provided.

The structure of the museum, outside and in, refers to the Shearwater setting. Pickard sought "to impart through materials, colors, textures, and qualities of light the context in which the artist lived and worked." He compares the exterior to an oyster shell, "rough, gray, concealing," made as it is of grey-stained redwood lap siding. The roof is made of galvanized steel. The materials, common in the area, resemble those used in several buildings at Shearwater. (See plate 6.) Inside, a soft, luminous effect, suggestive of mother-of-pearl, is obtained with pickled yellow pine walls and light oak flooring, the latter meant to recall the sands of Horn Island where so many of the images on display were captured. (See plate 7.)

The approach to the cottage mural as it now stands in the museum is thus no less Andersonian than the approach to it at the cottage was. In a sense, it is more concentratedly so, since the approach is through an anthology of Anderson's works. The careful selection and arrangement of his works, each cleaned, restored, and set to advantage in the museum galleries, allow the viewer to appreciate, more readily than was ever possible at the cottage, that the mural is, as the artist's wife realized, "a living synthesis of Walter Anderson's unique relationship with life."

The Mural

The visitor approaches the little room through the nave-like long gallery of the Walter Anderson Museum of Art as people formerly did through the main room of the artist's cottage. As he enters the little room, the projecting back of the chimneypiece rises on the right. The viewer's first impression is of color suffusing the parts of the three walls that are visible. This resolves itself into a panoramic landscape of the coastline, with views out to sea. Upon closer inspection, one begins to recognize representations of local flora and fauna; the more carefully one looks, the more plants and creatures become distinguishable. Overhead is a giant flower, unfinished but recognizably a zinnia, which occupies most of the ceiling, and a few stars indicated; the zinnia does not immediately explain itself. Only after taking a few steps into the room and pivoting does one see, painted upon the plastered back of the chimneypiece, a female figure, enormous in the scale of the room, which most viewers take to be a goddess. She stands out from a dark bluish background nearly covered with oversized paintings of moths—who is she, and what relation can she bear to the zinnia above and the landscape all around?

Examining the mural in detail, we may find it illuminating to keep in mind Anderson's attitudes and convictions. In seeking what he termed "the conditional mode of being," he all but entirely severed normal family and social ties, which of course constitute "the dominant mode on shore." He sought to integrate himself in nature, where he did not welcome human intrusion. But if, for this, he had been diagnosed mentally ill, feared as violent and judged irresponsible in his human relations, and largely indulged as a hopeless case who could only be left to his fate when he "went to sea," Walter Anderson could counter with his own diagnosis of the dominant mode on shore and claim, as has been indicated, his own kind of normalcy.

He did so, for example, in the characteristically gnomic formulation, "No is the concentric." Unpacked in the light of many other utterances, this characterizes the normal citizen as self-centered or, at best, anthropocentric, rationally focused upon self-interest in the context of human relations and inevitably a nay-sayer as regards the whole of nature. Logically, if the nay-sayer is the concentric, perceiving the world only in relation to the self and as properly subordinate to self-interest, then "Yes is the eccentric," and Anderson made no apology for being an undoubted eccentric. (He spelled this word "ex-centric" in a passage thought to be crucial in interpreting the mural, which will be presented below. He seems to have made a buried pun, expressing not only an outward focus but identifying himself as a former "centric.")

In his best hours Walter Anderson was not the *alienado,* not the decorator, not even the islander. He was *Yes,* the ex-centric, voyaging

outward from self into nature, focusing his devoutly objective eye upon nature, seeking, as he put it, "acceptance" into nature, even claiming credit for helping Providence create nature in the process of his painting.

This was not Wordsworthian contemplation with its very human complacencies. Anderson sought passionate, literally physical union with nature. This occurred when he could satisfy what he called his "hunger" for "images" and "realize" them, that is, help bring his subjects fully into being, in the act of fixing them in sketches and paintings. It was like procreation. The compulsion to be an artist, to paint after his particular fashion, came over him, he once told his wife, "like a physical craving, like hunger or sex, a necessity, a burning, a pulling of the thread tighter and tighter. Anything can trigger it. With me, it's nearly always the light." The incessant hunt for images on his island often involved, as a matter of logistics, his bodily merging with nature as he rowed his skiff through whitecaps and fog, burrowed into the sand dunes, waded neck deep in lagoons, clung to the trunks and limbs of trees, and, on a climactic occasion near the end of his life, weathered the hurricane on Horn Island. But he sought these experiences for their own sakes as well, not just as necessary preparation for getting into position to draw his subjects as they flew or swam or crawled or climbed or hid shyly in reeds.

This theme of the merging of the human with the natural is illustrated ingeniously in the cottage mural, which summoned the world beyond his walls, an effect reinforced by the situation of the cottage.

Another of his themes, recurrent in his paintings and writings, is

the special relationship with Providence that he thought he enjoyed: his desire for oneness with other creatures and with the elements was providentially satisfied in the act of painting. Walter Anderson believed that nature "has within itself order," although a human witness, indeed a human lover, is required if realization through painting is to be achieved. Nature's response to the eye that is sufficiently objective and empathetic to deserve them will be "materializations" fully apprehensible only as ecstatic experience involving the rapid deployment of pencil and brush. Such experience might be communicable to the dominant mode on shore through chronicle and paintings, but he was never entirely certain. In his ambivalence, he produced the mural but locked it away, took no measures to preserve it—left it to Providence.

He was good-naturedly convinced that Providence, though often inept, was always well-intentioned toward him and presided attentively over his affair with Horn Island. As he noted in a log less than a year before he died, the island was accessible only to "celestial beings." "Providence," he wrote, "made an exception in my case." He had to stumble over obstacles to get there, obstacles ranging from psychiatric treatment to guilt over abandoning his family, to the physical hardships and irritations of sea-going in all weathers and life with mosquitoes in the open. He might arrive half dead; but, he once explained to his worried wife, "When I reach the island, the world is swept as clean as if Providence had just tossed it into place and I am the first man." He became "Adam in the Hat" (referring to the disreputable headgear that was his trademark even in Eden), busy not only naming

but painting the plants and animals. Adam might go properly naked except for the hat, which he needed to carry drawing materials and, on occasion, to clap over subjects that did not wish to sit for him. A day during which Providence was particularly efficient in supplying his hunger for images would be acknowledged in his logs as "a Halcyon Day," and the paintings he was able to produce at such a time were sometimes marked with an eye-like symbol, expressing, according to Mrs. Anderson, his appreciation.

A copy of Psalm 104 in his handwriting was found in the little room after Anderson's death. The discovery has encouraged the supposition that he thought of the mural as a painter's analogue to the psalm, which *The Interpreter's Bible* describes as a "meditation upon the power and providence of God's glory." As one studies the mural, the psalm seems increasingly apposite, not merely with respect to the celebratory tone but also to numerous details as well. Psalm 104 is addressed to the Lord

Who coverest *thyself* with light as *with* a garment: who stretchest out the
 heavens like a curtain.

It celebrates light, echoing Ikhnaton's hymn to the sun as the creative, organizing principle in nature, manifesting the Lord in His works:

He appointed the moon for seasons: the sun knoweth his going down.
Thou makest darkness, and it is night: wherein all the beasts of the forest
 do creep *forth*.

The young lions roar after their prey, and seek their meat from God.
The sun ariseth, they gather themselves together, and lay them down in their
 dens.
Man goeth forth unto his work and to his labor until the evening.

The psalmist recognizes that nothing is made for itself alone, but each is made for another, with man among the rest, so that the needs of all are fully met. Anderson, who asserted that images were as "meat to my mouth," would have ackowledged himself one among the creatures:

These wait all upon thee; that thou mayest give *them* their meat in due season.

Sunrise

T he east wall, to the left of the entrance, represents the sunrise. (See gatefold, panel 1.) Arrestingly, the dominant feature is not anything in the mural but the window around which the mural is composed. The window frame has been decorated with designs or pictographs of unknown meaning which emphasize the outward— "eccentric"—view. They may allude to borders that Adolpho Best-Maugard, who influenced Anderson's theory of painting, set as exercises. The Best-Maugard borders were composed of seven motifs: the spiral, the circle, the half-circle, two half-circles joined in a form resembling the letter *S,* and the wavy, the zig-zag, and the straight line. These are, according to Best-Maugard, "the seven most characteristic types of the archetype spiral" inherent in all forms. Anderson had independently invested the spiral with mystical significance and found in Best-Maugard confirmation of his notions. The borders he used around the windows, the door, and the ceiling of the little room probably had, for Anderson, symbolic values.

The ground beneath the east window is drawn in a receding perspective as if it might continue under the window and merge with the grade

outside. The morning light has not reached this area. It is the instant before sunrise, with stars still visible at the upper corners of the wall. At the providential moment, the sun will rise in the window and complete the composition by covering it with light. Every day, there will be, if not a sound and light show, at least a light show, lending the mural a dynamic quality. In the meantime, a cock set above the window against the radiance heralds the dawn. (See plate 8.)

We are looking at part of a landscape that continues on the other walls. To the left of the east window, we see a hillside sloping down to the beach, which, scalloped with inlets, continues to the horizon. On the hillside scampers a troupe of goats, the billy standing guard, facing the viewer. (See plate 9.) Such a herd used to be out at dawn in the vicinity of Gautier, and Anderson may have had the coastline there in mind. Moreover, the psalmist notes that, among the provisions of the Lord,

The high hills *are* a refuge for the wild goats

In the foreground of the space left of the window, sandhill cranes are rising. (See plate 10.) Beneath their feet, indigenous plants grow, most prominently the red woods lily. This and the other plants depicted—pipe wort, pitcher plant, primrose, and possum berry—are varieties found in ditches between Ocean Springs and Gautier.

To the right of the window, the coastline continues, rising to a bluff crowned with a tuft of trees and forming a headland. (See plate 11.) Distinguishable among the plants are white mallows and palmettos.

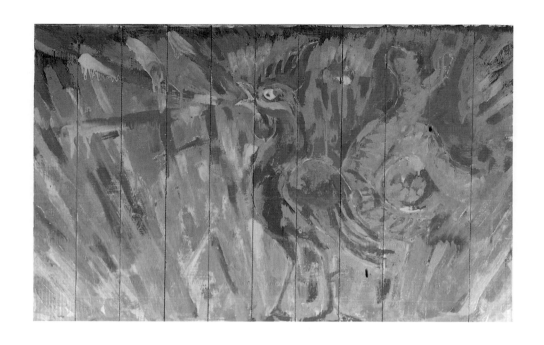

Plate 8. Detail, East Wall. Cock
heralding dawn above window

31

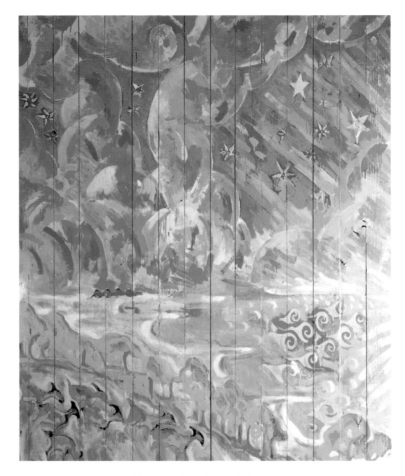

Plate 9. Detail, East Wall. Upper portion
of landscape left of window, with goats

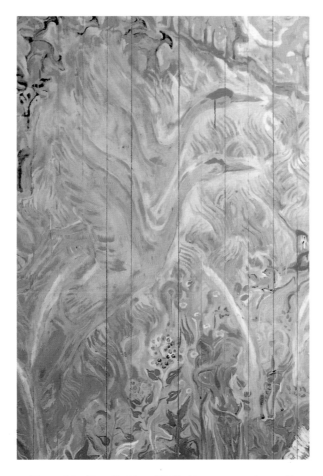

Plate 10. Detail, East Wall. Lower portion of
landscape left of window, with sandhill cranes

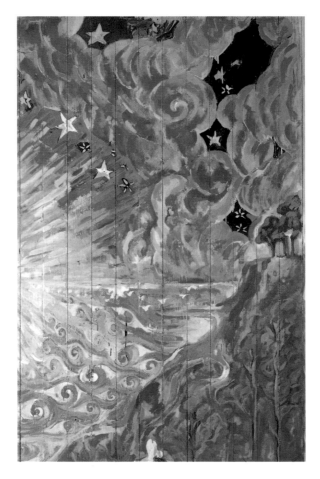

Plate 11. Detail, East Wall. Upper
portion of landscape right of window

34

Two blue jays take wing, and on the ground just below the windowsill a brown thrasher looks for insects, paying no attention to the horned lizard emerging from undergrowth. (See plate 12.)

The shadowy ground beneath the window is occupied by a toad on the far left, next to an opossum still going about its nocturnal affairs. (See plate 13.) Red fern is observable among the plants. A butterfly, perhaps a mourning cloak, dances.

Then comes a stalking cat. (See plate 14.) Anderson, a worshipper of cats, was likely to include one in any composition. This one may be taken as an allusion to the young lions in Psalm 104 that are summoned from their night's hunting by the rising sun. And given a cat in an evocation of dawn, an apostrophe to the cat that Anderson wrote may serve as a further gloss:

TO THE CAT

Thou who carriest the sun for a head,
A serpent for a tail,
And for feet four flowers
Which follow thee wherever thou dost go.

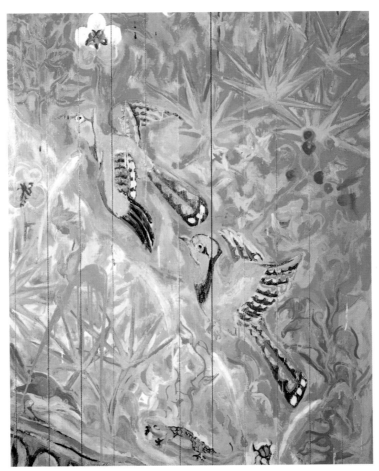

Plate 12. Detail, East Wall. Landscape
right of window, with cardinal and blue jays

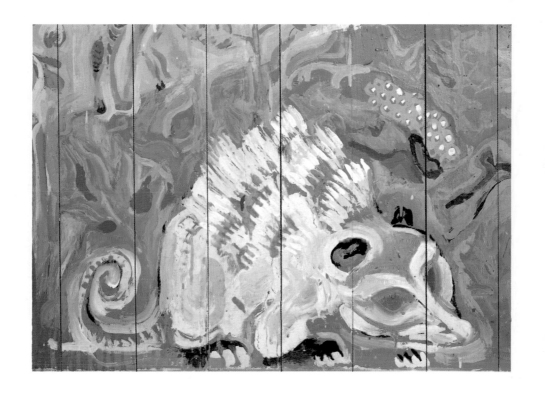

Plate 13. Detail, East Wall. Ground
beneath window, with opossum

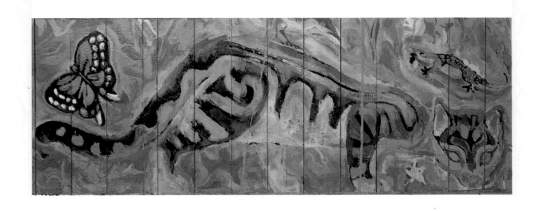

Plate 14. Detail, East Wall. Ground beneath
window, with cat coming in at dawn from hunting

Noon

ollowing the mural around the corner from the east to the south wall, the viewer looks south through the double window at noon, noting both movement in time and a change in the weather. (See gatefold, panel 2.) A squall has passed at sea beyond the headland, and a rainbow binds the east section to the south section of the mural. The continuing line of the horizon just below the tops of the windows in both walls contributes significantly to an observer's sense of the mural's wholeness. Above the south double window, the sun illuminates clouds in a clearing sky. (See plate 15.) The double window occupies a proportionately larger area of this wall than the single windows do in the east and west walls, so that the muralist's work here is more nearly united with the dense foliage outside, among which at the cottage swamp magnolia was prominent, as it will be again in time outside the museum. This more expansive opening of the artist's work to the world memorably communicates Anderson's "eccentric" perspective.

The space to the left of the double window is filled by the other half of the bluff or headland, which is divided by the corner. Beneath

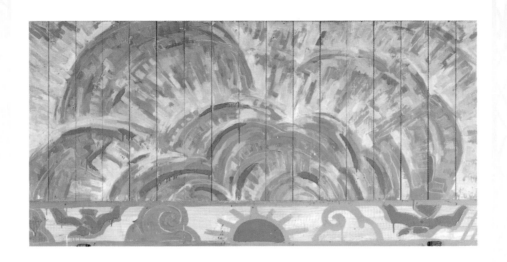

Plate 15. Detail, South Wall. Noonday
sun illuminating clouds above window

the rainbow flies an osprey—that species to whose survival Horn Island was as indispensable as it was to Walter Anderson's. (See plate 16.) In front of small trees with black fruit, perhaps elderberry, flaps a heron, its neck reddened by a trick of the light from the noonday sun. Nearby appear two insects with red and blue wings, the colors possibly rendering an ephemeral effect of light through gauzy wings. These may be wasp moths. They are joined by a dragonfly, just beneath which a spider lurks at the center of its exquisitely rendered web; nearly level with it perch a titmouse, a cardinal, and a red-winged blackbird. A second red-winged blackbird flutters up from the ground. The two red-winged blackbirds look greyish because, according to Mary Anderson Pickard, her father rendered the sheen of their feathers reflecting the sun. Rising above these is a stalky plant with white flowers, perhaps ragweed, with a pair of chickadees below. (See plate 17.)

Receding marshy ground at floor level under the window seems contiguous with the ground outside. First, at the left, is a turtle among flowers. Anderson left a mythopoeic statement on the turtle that invests this apparently insignificant creature with great charm and helps illuminate the work as a whole:

In the dark and middle ages, man made and still makes an image and from that image erects a world. Every form in nature, cat, dog, pig, rat have all had worlds made for them, despise them as you, as man will, each one has owned his world. So that for the turtle, crawling low upon the earth and bearing the burden of his shell, the flowers were made, stars brought close and hung just above his head to fill the space between the blades of grass.

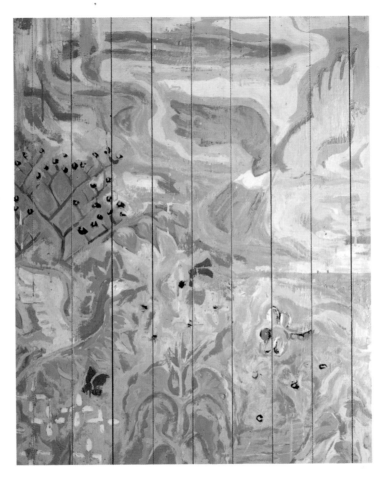

Plate 16. Detail, South Wall. Space
left of window, with osprey in flight

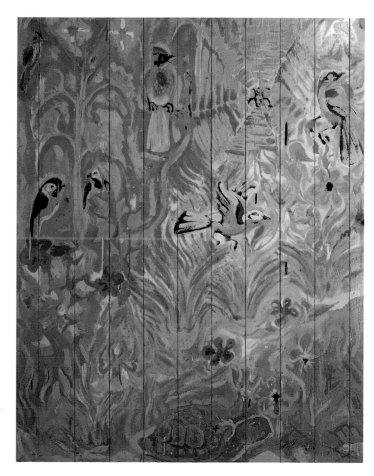

Plate 17. Detail, South Wall. Lower
portion of space left of window

43

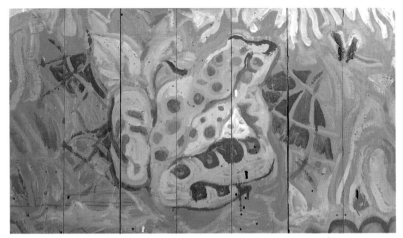

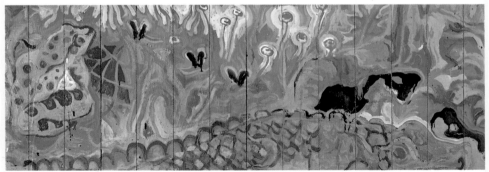

Plate 18. Detail, South Wall.
Bullfrog on ground beneath window

Plate 19. Detail, South Wall.
Alligator on ground beneath window

Providence, it will be recalled, had made a world for Anderson, despised as he might be, and now he was painting his world and the worlds within upon his walls.

Next to the turtle sits a handsome bullfrog touched with scarlet as the sun shows through his profile. (See plate 18.) Near the frog can be glimpsed patterned grasses and damsel flies. Basking across the width of the left window is an alligator. He stands in, perhaps, for "that leviathan," whom, the psalmist says, the Lord has made to play in the sea, great and wide. (See plate 19.) Beyond the alligator's snout are a skink, touched with scarlet like the frog, and the fur of one of the rabbits at the right. (See plate 20.) The rabbits may echo the psalmist's "conies" that find their refuge in the rocks. Dogtooth violets appear at the feet of the first rabbit, and between the rabbits is an alert towhee. (See plate 21.) All these creatures are surrounded by plants, mushrooms to the left and bluish stokesia to the right. The pitcher plant beneath the sill repeats the shape of a rabbit's ear. The deliberate repetition of patterns and the juxtaposition of warm and cool colors produce a vibrating effect in certain lights, according to Mrs. Pickard.

Flowing off to the south beyond the windows is a shallow stream in which a doe has come to drink. (See plate 22.) The psalm offers a parallel:

He sendeth the springs into the valleys, *which* run among the hills.
They give drink to every beast of the field: the wild asses quench their thirst.

Above the doe's head, a red-winged blackbird flies up from wild grain

bordering the stream, while feeding in the stream at the doe's hooves are two gallinules. There is also a rail hidden near the gallinules and, among the stalks of grain, a bittern sits. The stream is cut in cross section at the baseboard, with two fish swimming in it. (See plate 23.) In the upper right corner of this wall, a flock of ibis is wheeling up into the sun, some shown black and some white catching the sunlight as the flight pattern curves back on itself. (See plate 24.)

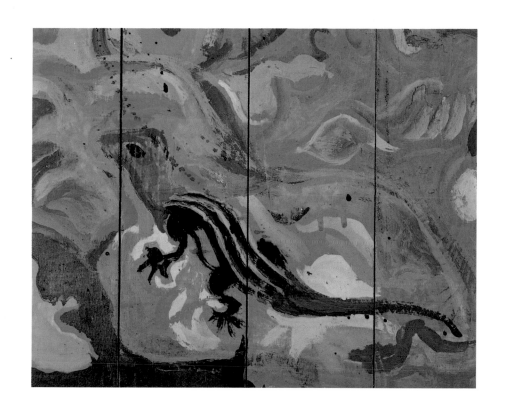

Plate 20. Detail, South Wall.
Skink on ground beneath window

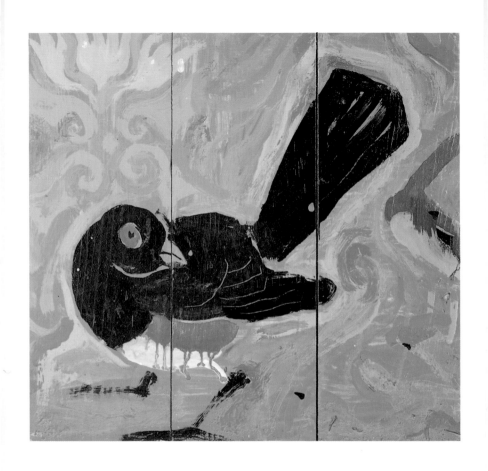

Plate 21. Detail, South Wall.
Towhee on ground beneath window

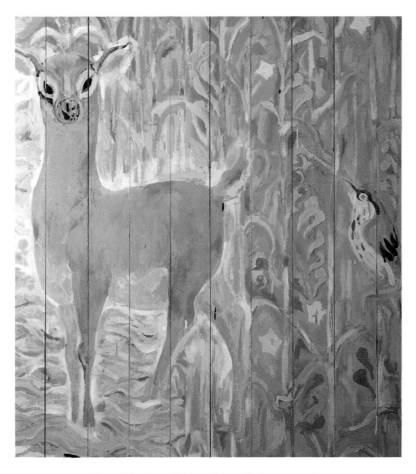

Plate 22. Detail, South Wall. Space right
of window, with doe standing in stream

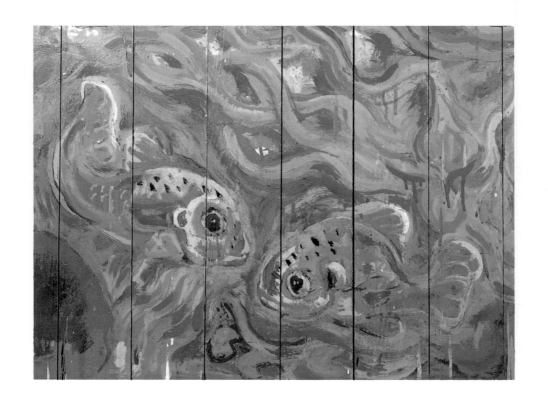

Plate 23. Detail, South Wall. Fish swimming
in cross-section of stream, right of window

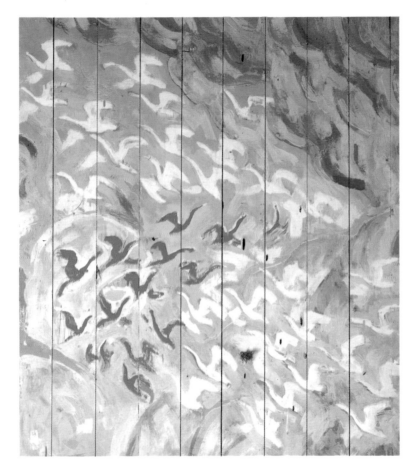

Plate 24. Detail, South Wall. Upper portion
of space right of window, with ibis in flight

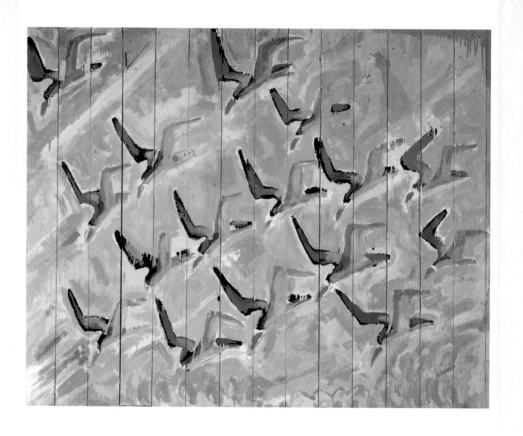

Plate 25. Detail, West Wall. Upper portion
of space right of window, with black skimmers

Sunset

The line of the horizon runs across the south wall and around the corner to the west where it is lost, except for glimpses of blue sky, in trees and other growth and the explosion of color at sunset. (See gatefold, panel 3.) The mural here represents, more particularly than in the other sections, the scene outside the cottage, looking toward the municipal harbor. Pouring into the cauldron of the sun is a flock of the eponymous shearwaters—actually black skimmers—which habitually flew over the harbor at this time of day. (See plate 25.) The blue visible through the pine trees at the left of the window and through the fruiting persimmon tree at the right is probably the sky above the harbor. (See plate 26.) A persimmon tree grew just outside the window, beyond the painted one. (See plate 27). The dynamic effect of the mural, giving the sense of time passing and light changing through the day, is intensified when the actual sunset occurs at the appointed instant through the window, just as the sunrise appeared in the east window.

Prominent among the vegetable motifs here are what look at first glance like large stylized blue flowers with unusual cruciform stamens

growing on both sides of the window. These have been identified, however, by Mrs. Pickard as clusters of wet ivy leaves. Ivy grew outside the cottage, and when the leaves were wet and the sun was behind them, they looked bluish. The sparkling, beaded crosses she correlates with some of her father's watercolors that represent the subject through wet window screens in which drops of water caught in the mesh, glistening cruciform, are faithfully recorded in the foreground. (See plate 28.)

Thick, twisted liana-like vines to the left and right of the window are probably Virginia creeper, and this, too, was to be found in a tangle outside. Growing up at the right of the window is a moonflower vine, with blossoms opening as night falls. A tendril wreathes behind the window to emerge at the left. The moonflowers, as well as the magenta azaleas and naked lady lillies that appear under the window, were actually present beyond the wall of the cottage at Shearwater. (See plate 27.)

Also beneath the window appears another cat, attended by two butterflies, setting out on cue for the night's hunting like the young lions in Psalm 104. (See plate 29.) Addressing the Lord, the psalmist notes among the providential arrangements,

Thou makest darkness, and it is night: wherein all the beasts of the forest
 do creep *forth*.
The young lions roar after their prey, and seek their meat from God.

Anderson had observed another nocturnal aspect of the cat, the sparks of static electricty visible in its fur, asking,

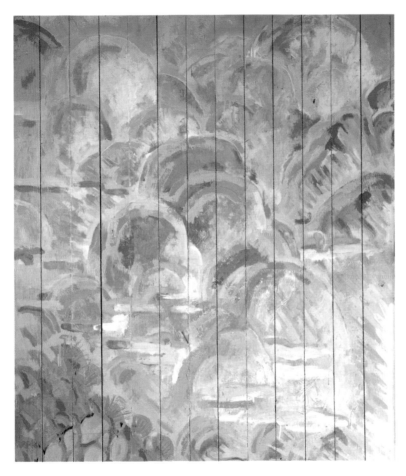

Plate 26. Detail, West Wall. Upper portion
of space left of window, with clouds

Friend of witches and friend of stars,
What strange force do you carry in your fur?
Whose black velvet dress is sprinkled with pearls on a dark night,
Whose body is alive with white fire?

Before turning around to examine the north wall, one should pause to appreciate the unity of the east, south, and west walls, which can be missed if attention is directed exclusively to each in turn. Unity is achieved, first, by representation of the changes in light during the course of a day from dawn through noon to evening, and then night on the north wall. The first three segments are further tied together by the line of the horizon, which disappears in the vegetation depicted on the west wall. Gregory Free, in preparing the mural for moving, had occasion to work from the upper rungs of a stepladder where he gained the perspective Anderson must have had. The walls lose some degree of verticality and seem to spread out more nearly level with the viewer, who gets a strong impression of the panoramic sweep of the horizon.

GATEFOLD

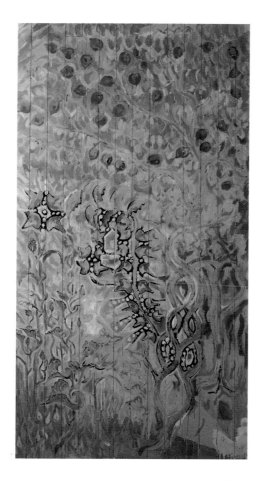

Plate 27. Detail, West Wall. Scene right of window,
with persimmon tree, Virginia creeper, and moonflowers

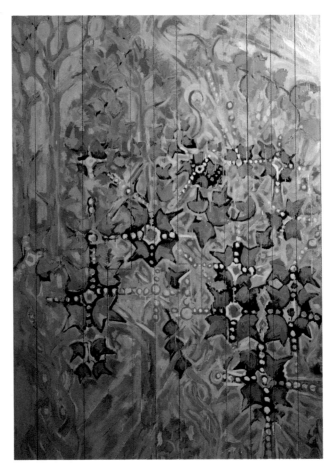

Plate 28. Detail, West Wall. Landscape
left of window featuring wet ivy leaves

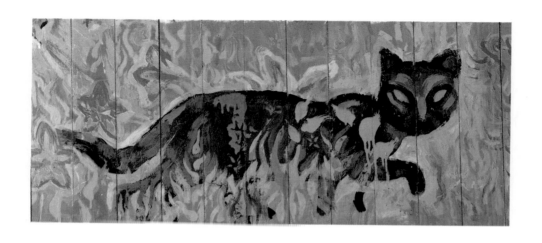

Plate 29. Detail, West Wall. Ground beneath
window, with cat setting out at nightfall to hunt

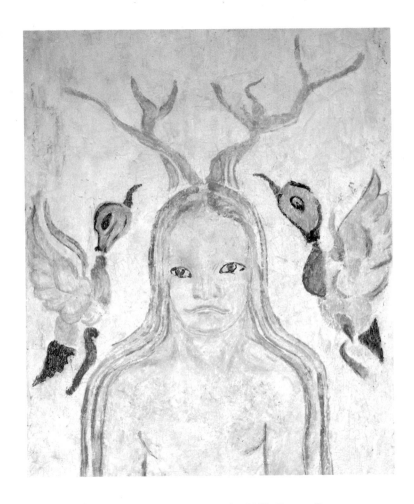

Plate 30. Detail, North Wall. Face of
goddess-like figure on chimneypiece

Night

The north wall represents night and thus completes the time scheme of the mural as a whole. Yet it differs distinctly from the other three walls. In the first place, it is not a landscape but merely the night air filled with a riot of moths rendered many times life size. (See gatefold, panel 4.) Instead of having a window that draws the eye outward as in the other three walls, the north wall presents two structural features, the back of the chimneypiece and the closed door into the main room of the cottage, which Anderson conspicuously did not use to introduce the "eccentric" perspective for which I have argued in the east, south, and west segments. Finally, the north wall appears the least finished, a circumstance that makes interpretation here comparatively problematical.

Some viewers, including members of the Anderson family, think the north wall and particularly the chimneypiece were left unfinished intentionally and so, paradoxically, were as finished as the artist meant them to be. May the unpainted white plaster of the chimney be taken to represent light, either from a spotlight or emanating from the central figure, which is thus contrasted with the backdrop of night air?

I think, rather, that the north wall and chimneypiece are unfinished in the ordinary sense that the artist did not get around, for unknown reasons, to completing them. It seems evident, at least, that the lower part of the wall to the left of the chimney, the lower left corner of the door panel, and the border around the door were left unfinished in this simpler sense.

The dominant structural feature here is the back of the chimney and fireplace, which projects into the room and which Anderson has used to introduce in the most emphatic way into his otherwise unpeopled Eden a female human form with mythological or divine attributes. This figure seems to be that of a young girl. The face looks like that which Anderson drew or painted in portraits of his daughter Mary, so that it would appear that he had given a prominent place not simply to humankind but to his largely abandoned family in his "land of infinite refreshment." (See plate 30.) "I know now," Mrs. Anderson was eventually able to write, "that the alienated must seek forever the means of reentry into the world of man." The chimneypiece, protruding into the mural space, gave Anderson, exponent of "the eccentric," an opportunity to acknowledge the value of "the concentric."

If so, he was concurring in the psalmist's sane acknowledgment that Providence accommodates man along with the other creatures. Just as the Lord "causeth the grass to grow for the cattle," so does he cause to grow

. . . herb for the service of man: that he may bring forth food out of the earth;

And wine *that* maketh glad the heart of man, *and* oil to make *his* face to shine, and bread *which* strengtheneth man's heart.

The viewer's sense of a humanistic quality present in the north wall is confirmed by the knowledge that it memorializes occasions when Anderson and his family went mothing. He resolved one autumn to collect specimens of all the local moths, with which, as nocturnal creatures, he had a special affinity. He had trained himself to hunt by night as well as by day the images he craved. "This man who translated into visual form the 104th Psalm, Ikhnaton's Hymn to the Sun, upon the walls of a special small room in his house; this man whose heart actually beat faster at the words in Genesis, 'Let there be light'; this man who pursued in myth and art history the Sun-God's presence; this man made little difference between day and night," according to his wife.

"He could see in the dark like a cat," she wrote (the cat that "carriest the sun for a head"). "He knew so well that there is a time for everything, a time for sleep, but there just wasn't enough time for all the other things, and so he had trained himself to use the night as if it were the day. He felt a kinship with those old cave-dwellers who, wakeful, watched the leaping shadows of the entrance fire on the walls of the cave and, rising, traced with a stick's burnt end their own succession of forms upon the walls." It happened that Mrs. Anderson suffered from night-blindness and was thus specially disqualified for joining her husband, as he sometimes forced her to do, in his nocturnal ventures.

The painted moths are identifiable as species that could be caught in the area around the cottage. Mrs. Anderson recorded that the family painted tree trunks with sugar and beer in the late afternoon, used a floundering light after dark, and "reaped our drunken harvest." At upper left of the north wall is the forester or peach moth, next a small blue moth, and then the rare *Composia fidelissima* in its midnight blue with red at the shoulders and white spots bordering the wings. In a diagonal below this group, Anderson has disposed, from left to right, a female io, a buck, and a male io. In a third arrangement below these, he placed a Polyphemus, another buck, and a Cecropia, while toward the lower left corner is what appears to be a small rose moth, balancing a pair of rose moths above the door to the right of the chimney.

Particular attention should be focused upon the large patterned form painted to the left of the chimney at the level of the female figure's shoulder. This seems to be a Morpho moth emerging from its chrysalis, one of those "materializations" in nature that especially excited Anderson. (See plate 31.) Mary Pickard points out that, in representing the literal metamorphosis of life, he has marked it with his Providence symbol. This device, eye-like (and so suggesting Providence) and often associated with the sun in Anderson's paintings, but here seeming also to incorporate the spiral to which he attached mystical significance, appears below the metamorphosing wing. An example of this symbol, recurrent in his watercolors, can be seen in plate 32. If, as his wife understood it, the symbol denoted an accolade for Providence when it had produced for his painterly convenience a Halcyon Day, his use

of it in the mural suggests that an accurate title for the work would be "A Halcyon Day at Shearwater."

To the right of the chimney, the night air spangled with moths continues. Beginning at the top, the moths consist of a great odorato in profile with wings folded, an Ailanthus, and a Sphinx, while dimly visible above the right upper corner of the door an Imperial is in flight.

The treatment of the door presents some difficulty for the interpreter. Although the moth motif continues in the Cecropia, done in huge dimensions on the upper part of the panel, the door does not merge with the wall. Anderson was in the process of accentuating the door frame with the same sort of border he used for the window frames, but here presumably he did not wish to emphasize the opening—the door is closed. The immense moth, a Cecropia, is displayed not against clear night air like those on the surrounding wall but among five-petalled white flowers, with, just beneath the moth, a bluish star. The lower two-thirds of the panel is filled with puffy forms, which some people see as clouds, probably because of the dark blue patch toward the bottom, which suggests a break in clouds. What is visible through the break, however, is not a star as might be expected but another flower. Having treated the door as an entity, Anderson established it as in some degree competitive with the chimney figure, but to what purpose remains obscure. (See plate 33).

The goddess-like figure painted on the plastered back of the chimney looms inside the enclosing walls covered with Anderson's painting of the world he owned as he said the turtle and every creature, however

Plate 31. Detail, North Wall. Space
left of chimney, with metamorphosing moth
showing Anderson's Providence symbol

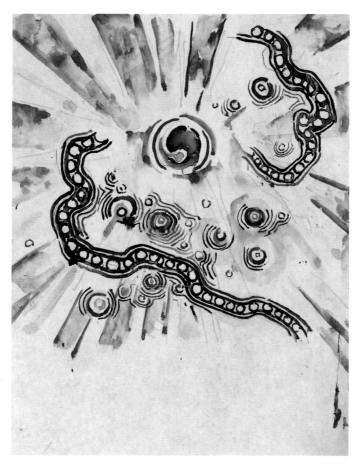

Plate 32. Watercolor by Anderson
exemplifying his use of the Providence symbol

despised, owned each its world. The face of the figure indeed appears to recall that of the young Mary Anderson, but the figure is one of a series of comparable figures of both sexes identified among Anderson's works in various media by Mary Pickard. She notes that certain elements persist, such as the posture, the mallards on either side of the head, and the antler-like forms above. The figure is usually associated with water, either standing in it or, perhaps, walking on it. One, at least, refers to Thetis, the sea nymph and mother of Achilles, and another to Rima, the Bird Girl; but the Anderson family thinks the ultimate reference may be to the Egyptian goddess Isis. In her most familiar image, Isis wears upon her head cow's horns curving up to embrace a sphere representing the sun, which in Egyptian mythology—and in Anderson's—stands for the creative principle. The horned headgear of Isis looks like the antler-forms of Anderson's chimney figure, and the association of Isis with a great river—the Nile—was probably not lost on Anderson.

For, of all the versions of the chimney figure, the one that most directly illuminates it and of which it is probably an adaptation was Anderson's large wood sculpture of "Father Mississippi," carved from the trunk of a tree in the early 1950s. This central figure representing the river was surrounded by a changing group of other wood sculptures of animals and plants. Only one element of the group has survived, but a color snapshot of it exists and, more importantly for the present purpose, a watercolor of it that Anderson painted. (See plate 34.)

The central male figure was crowned with reddish brown antler-

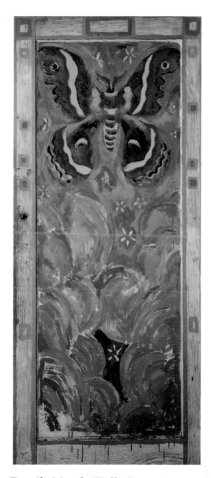

Plate 33. Detail, North Wall. Door into main room
of cottage, with Cecropia moth and cloud-like forms

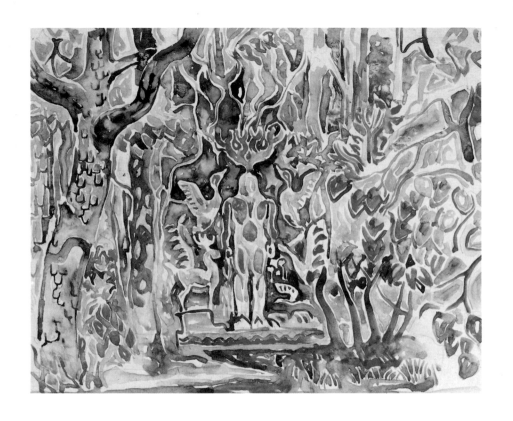

Plate 34. Water color by Anderson of his sculpture
group, "Father Mississippi," in woods outside his cottage

like forms representing tributary streams which, merging with his long hair and beard, flowed down his body to his feet. He and the attendant figures stood upon a platform, the leading edge of which was painted in a wavy pattern with thin wood cut-outs of fish attached to produce the effect of a cross section of the river. On the right side of the photograph appeared a buck and a cat. To the left, from the bottom upward, were fixed an opossum, a gull, some mallows or perhaps thistles on dowel stems, a great blue heron, and a blue jay, and then the pair of mallards framing the head of Father Mississippi.

The goddess in the little room is unmistakably a feminized version of Father Mississippi. Above her head, Anderson has once again represented the tributaries of the river and once again, merging with her hair, they flow down the body. Identification of the figure with the Mississippi River confirms the orientation of the entire mural. Set against the north wall, it divides the east from the west segments and the stream may be taken as flowing properly southward. Anderson started to paint on the fireplace returns roadrunners and cactus to the west and, to the east, a Turk's cap lily, a turkey gobbler, and what is called in live oak country an "eastern" oak leaf. (See plates 35 and 36.)

Around the goddess Anderson imported creatures as he had used them in the sculpture group, repeating the buck deer and the mallards. In the foreground, he painted a rabbit to the left and to the right a turtle. We see pitcher plants, a woods lily, and other plants beginning to appear. It seems likely that Anderson expected to treat the fireplace

back as he did the spaces under the windows in the east, south, and west walls, with the ground receding and filled with plants and animals.

Now the watercolor that Anderson painted of his sculpture group "Father Mississippi" not only permits a comparison that confirms the identification of the figure on the chimney with the river but also illustrates the Andersonian "eccentricity" of the mural as a whole. In setting the sculpture in the woods outside his cottage, Anderson accorded the human artifact no pride of place. It took no priority among the trees and shrubs and was itself only a tree transformed. The cottage stands thus; and I believe that, in incorporating the view outward through the windows in the mural, Anderson sought the union with nature to which he was addicted. The effect is unmistakable in the watercolor, in which he has typically painted not so much the subjects—the sculpture, the trees—as the spaces around the subjects, filling the surface with patterning from which the subjects only partially emerge.

In painting not a figure in a landscape but an inclusive environment in which the figure is neither more nor less in focus than other elements, Anderson ran counter to humanistic taste and anthropocentric prejudice. In him, humanism was subsumed in an environmentalism more radical than anything commonly expressed by ecologists and conservationists. His attitude contradicted the more common view as memorably rendered in Wallace Steven's poem, "Anecdote of the Jar," which Anderson copied into a notebook containing verse that

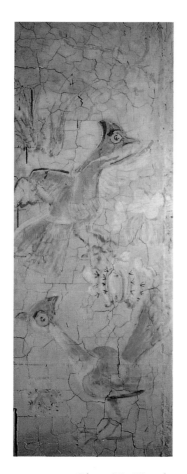

Plate 35. Fireplace return, west side

Plate 36. Fireplace return, east side

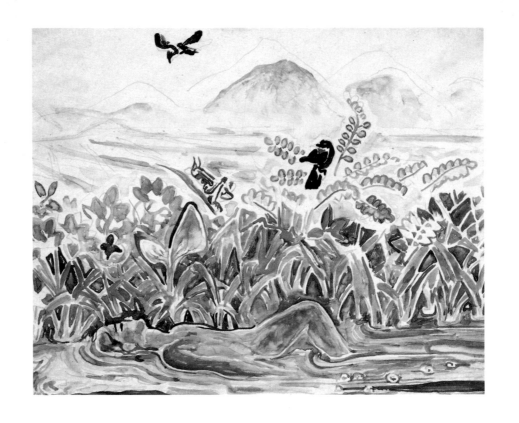

Plate 37. Watercolor by Anderson
showing him lying in a nullah

interested him. Stevens recounts placing a round jar upon a hill in Tennessee. The result was that

> It made the slovenly wilderness
> Surround that hill.

Not so with Anderson's sculpture in the woods. He would not, in the first place, have characterized wilderness as "slovenly" and did not desire to render it "no longer wild" as the jar does. Stevens says the jar "took dominion everywhere." Anderson would see, as Stevens does, that the jar was "gray and bare" and would be dismayed that the jar, symbolizing the human element,

> . . . did not give of bird or bush,
> Like nothing else in Tennessee.

Anderson's attitude sometimes led him to the point of integrating himself bodily into nature. He did a watercolor of himself absorbed into what he liked to call a nullah, that is, a puddle or bog. (See plate 37.) He lies naked on his back in shallow water and mud, holding still while the diverse life around him accepts him and resumes normal ways. In the meantime, he contemplates heaven. If then a minnow should nibble his nipple or a dragonfly perch on his prominent nose, he was enchanted. Once in such a situation, a snake slithered away in the mud beneath him and he restrained the impulse dating from the Fall to leap up and bruise its head: the nullah was prelapsarian, restorative. When one of his children, then an infant, was dangerously ill, he immersed the baby in a nullah to restore him.

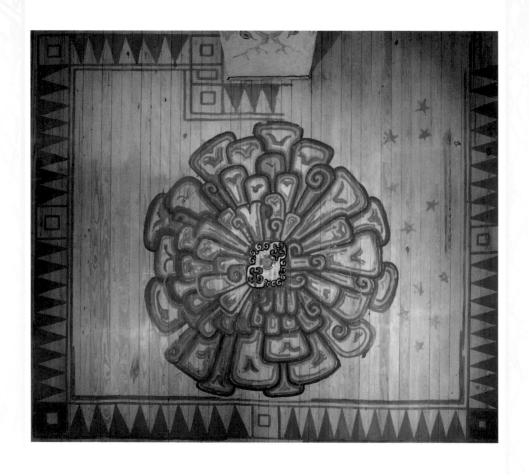

Plate 38. Ceiling with zinnia, "most
explosive and illuminating of flowers"

CEILING
Zinnia

Finally, one looks up to the ceiling, which Anderson has filled almost entirely with an open zinnia centered on the electric light bulb, with a scattering of stars in the background on the night side. (See plate 37.) The zinnia is like an oversized molded plaster medallion from which an elaborate crystal chandelier might be hung. This association seems humorous, given that when Anderson painted the ceiling, the light bulb dangled humbly on an electrical cord. After his time, the cord was removed and the bulb screwed into a socket in the ceiling. Like the north wall, the ceiling is not finished; but the zinnia is completely drawn, and enough of the color has been applied for us to know it was to be a rich magenta. He was working with reddish-pink and blue, outlined in gold, which stresses the symbolic value of the flower. Given the organization of the mural according to the passing hours of the day, the zinnia may represent the sun at zenith. The flower is centered upon a source of light, and the painter has used light as the organizing principle of his mural in a way which I think illustrates the celebratory theme of Psalm 104.

Overwhelmed by the splendor of the creation as a spectacle and

by its orderly dynamics, taking these as an argument from design not merely for the existence but for the glory of god, the psalmist bursts into praise:

O LORD, how manifold are thy works! in wisdom has thou made them all:
 the earth is full of thy riches.

The cottage mural displays, in the same spirit, the manifold works of the Lord in their Gulf Coast materializations.

Anderson left a lyric about zinnias which I believe may be applied as a gloss upon the mural confirming the interpretation I have advanced. Among the drifts of papers found in his cottage after his death was a sheet with these lines:

> Oh, Zinnias,
> Most explosive and illuminating
> Of flowers,
> Summation of all flowers,
> Essence of excentric form,
> Essence of concentric form!

Here are the terms, "excentric" and "concentric," which evidently had almost technical meaning in his private philosophy, brought into relation with "form." Since Anderson wrote correctly even in his most casual jottings, I believe that the spelling "excentric" is here intentional, and possibly a pun. Years after his death, Mrs. Anderson noticed, scribbled on the back of a watercolor of a great blue heron, an observation in

which, to the enlightenment of others, his special usage occurs. "Fear," Anderson wrote, "is either unity or chaos—if all of the faculties are brought together for the sudden effort, it is unity—if they disintegrate it is chaos. If in the single unit both eccentric and concentric forces go into the construction, they balance each other and the machine would not function." This testifies to his consistent association of the eccentric with the objective, celebratory orientation and the concentric with the human subjective. I infer that as a painter he tried to rule out human relationships altogether; otherwise, "the machine would not function." Only at the center and source of governing light, symbolized in his mural by the zinnia, could he conceive of "both eccentric and concentric forces" going into the construction in a functional way.

I suggest that in the cottage mural Anderson used the fenestration that happened to be a structural feature to bring the eccentric forces into the construction, took advantage of the chimneypiece, which happened to project into the room, to do honor at last to the concentric forces, and enhanced the light fixture that happened to be overhead. The mural renders without resolving Anderson's tension. Some people are discomfited. They need focused human interest. Most viewers, however, respond to Anderson's "eccentricity" as joyous affirmation of the world, all the more poignant in overbalancing, as it does in the mural, the equally profound values of "concentricity." Seeking, finding, but only precariously maintaining himself in "the conditional mode

of being," Walter Anderson could concur with the psalmist when he declared,

I will sing unto the LORD as long as I live: I will sing praise to my God
 while I have my being.
My meditation of him shall be sweet: I will be glad in the LORD.

CHRONOLOGY

1903	Born in New Orleans, September 29
1915-18	Attended St. John's School, Manlius, New York
1919-22	Attended Manual Training School, New Orleans
1923	Attended Parsons Institute, New York City
1924-28	Attended the Pennsylvania Academy of the Fine Arts, Philadelphia
1925	Received Packard Award for animal drawing from the Pennsylvania Academy
1928-29	Traveled and studied in France on Cresson Award from the Pennsylvania Academy
1933	Married to Agnes Grinstead, April 29; remodeled and began residence in cottage at Shearwater
1935	Mural, Ocean Springs, Mississippi, High School (W.P.A. commission)
1937	Mural, Indianola, Mississippi, Post Office (W.P.A. commission, never completed due to illness); birth of daughter, Mary, December 8

1937-38	Hospitalized for mental illness
1939	Hospitalized twice for mental illness; birth of son, William Walter, October 25
1941-46	Lived with family at Oldfields
1944	Exhibition of Shearwater Pottery by Peter Anderson, decoration by Walter Anderson, Brooks Memorial Art Gallery, Memphis, Tennessee; birth of daughter, Leif, May 23
1947	Birth of son, John Grinstead, March 12
1947-65	Lived alone in cottage at Shearwater and on islands offshore
1948	"Folktales and Fantasy," exhibition of block prints, American Association of University Women and Brooks Memorial Art Gallery, traveled through southeast and to Brooklyn Museum, Brooklyn, New York
1949	Traveled in China
1950-51	Mural in Community Center, Ocean Springs
1951	Traveled in Costa Rica
1951?-53	Mural in cottage at Shearwater
1964	"Fledgling Birds," Brooks Memorial Art Gallery
1965	Died in New Orleans, November 30
1967	"The World of Walter Anderson," Brooks Memorial Art Gallery, traveled 1968-69, exhibition catalog published

1970-78	Several small exhibitions
1973	Publication of *The Horn Island Logs of Walter Inglis Anderson,* edited, with an introduction, by Redding S. Sugg, Jr. (revised edition, 1985)
1978	Telecast of *The Islander,* produced by Mississippi ETV and repeatedly shown on Public Broadcasting System; publication of *A Painter's Psalm: The Mural in Walter Anderson's Cottage,* by Redding S. Sugg, Jr. (revised edition, 1992, subtitled *The Mural from Walter Anderson's Cottage*)
1979	"The Shearwater Legacy," Mississippi State Historical Museum, Jackson
1980	"Sea, Earth, and Sky: The Art of Walter Anderson," Mississippi State Historical Museum, exhibition catalog published; publication of *Walter Anderson's Illustrations of Epic and Voyage,* edited with an introduction, by Redding S. Sugg, Jr
1982	Publication of *Robinson: The Pleasant History of an Unusual Cat,* written and illustrated by Walter Anderson, with an afterword by Mary Anderson Pickard
1983	Publication of *Anderson's Alice: Walter Anderson Illustrates Alice's Adventures in Wonderland, by Lewis Carroll,* with a foreword by Mary Anderson Pickard
1984	"Walter Anderson for Children," Mississippi State Historical Museum, traveled by Southern Arts Federation, exhibition catalog published; "Walter Anderson's New Orleans," Louisiana

World Exposition, New Orleans; publication of *An Alphabet,* by Walter Anderson

1985-86 "The South on Paper," traveled by Robert M. Hicklin, Jr., Inc.

1986 "Walter Anderson's Calendar," Mississippi State Historical Museum, traveled by Southern Arts Federation; "Realizations: The Art of Walter Anderson," The Pennsylvania Academy of the Fine Arts, traveled 1986-87, exhibition catalog published; publication of *The Walter Anderson Birthday Book*

1987 "The Birds of Walter Anderson," traveled to universities, art, and nature centers; publication of *The Magic Carpet and Other Tales,* retold by Ellen Douglas with the illustrations of Walter Anderson

1988 "Walter Anderson's New Orleans," New Orleans Museum of Art; "An American Master: Walter Anderson of Mississippi," Brooks Memorial Art Gallery; "The Watercolorists: Walter Anderson and His Peers," Luise Ross Gallery and Vanderwoude Tananbaum Gallery, New York, N.Y.; "Show and Tell: Artists' Illustrated Letters—1540-1968," The Grey Art Gallery, New York University, New York, N.Y.; publication of *The Living Dock at Panacea,* by Jack Rudloe, with illustrations from the works of Walter Anderson

1989 Publication of *Approaching the Magic Hour: Memories of Walter Anderson,* by Agnes Grinstead Anderson; "Walter Anderson— Witness to Wilderness," University Art Museum, Lafayette, Louisiana; "The Birds of Walter Anderson," Fairhope, Alabama; "Walter Anderson: The Birds," Luise Ross Gallery, New York,

N.Y.; "Walter Anderson," Tilden-Foley Gallery, New Orleans, Louisiana; "Walter Anderson for Children," Greenville County Museum of Art, Greenville, South Carolina; "Mississippi Museum of Art's Walter Anderson Collection," Mississippi Museum of Art—Gulf Coast, Biloxi

1990 Publication of *Birds* by Walter Anderson with an introduction by Mary Anderson Pickard

1991 Publication of *On the Gulf,* by Elizabeth Spencer, illustrated with the calendar drawings of Walter Anderson; opening of Walter Anderson Museum of Art, May 5-6

Library of Congress Cataloging-in-Publication Data

Sugg, Redding S.
 A painter's psalm: the mural from Walter Anderson's
cottage / by Redding S. Sugg, Jr.—Rev. ed.
 p. cm.
 ISBN-0-87805-560-6
 1. Anderson, Walter Inglis, 1903 - 1965—Themes,
motives. 2. Mural painting and decoration. American—
Mississippi—Ocean Springs—Themes, motives. 3. Walter
Anderson Museum of Art. I. Title.
ND237.A6426S89 1992
751.7′3′097307476212—dc20 92-1355
 CIP